Ink & Blue Notes

Authored and Illustrated by Darryl Z. Oates

Volume I.

Music Coloring Books

Location Hartford, CT USA

Publication Year October 19, 2016

Published by Lulu

This is a coloring book of musical sketches created in the Hartford Connecticut area.

© 2016 Lulu Author. All rights reserved.

ISBN: 978-1-365-47065-3

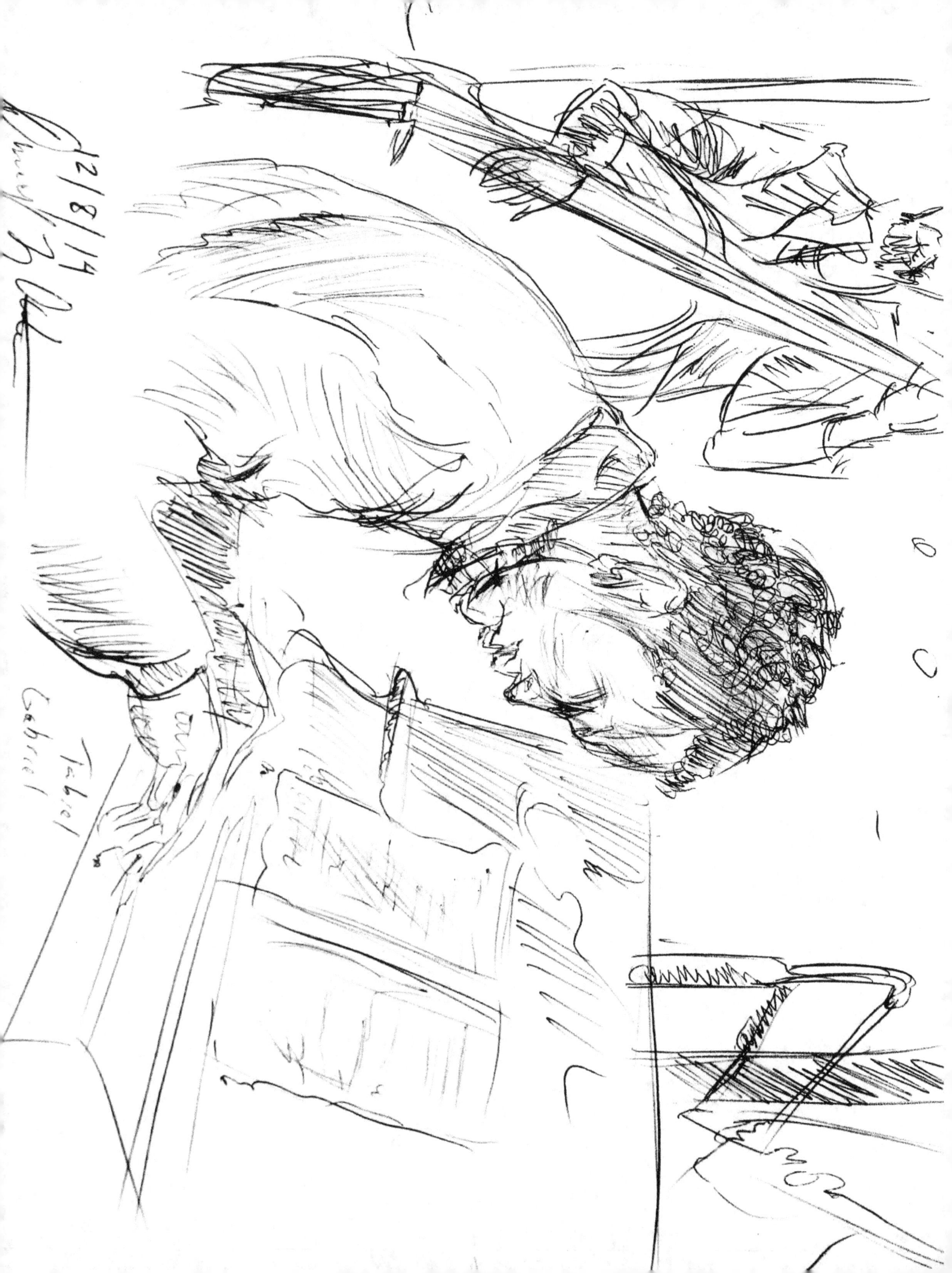

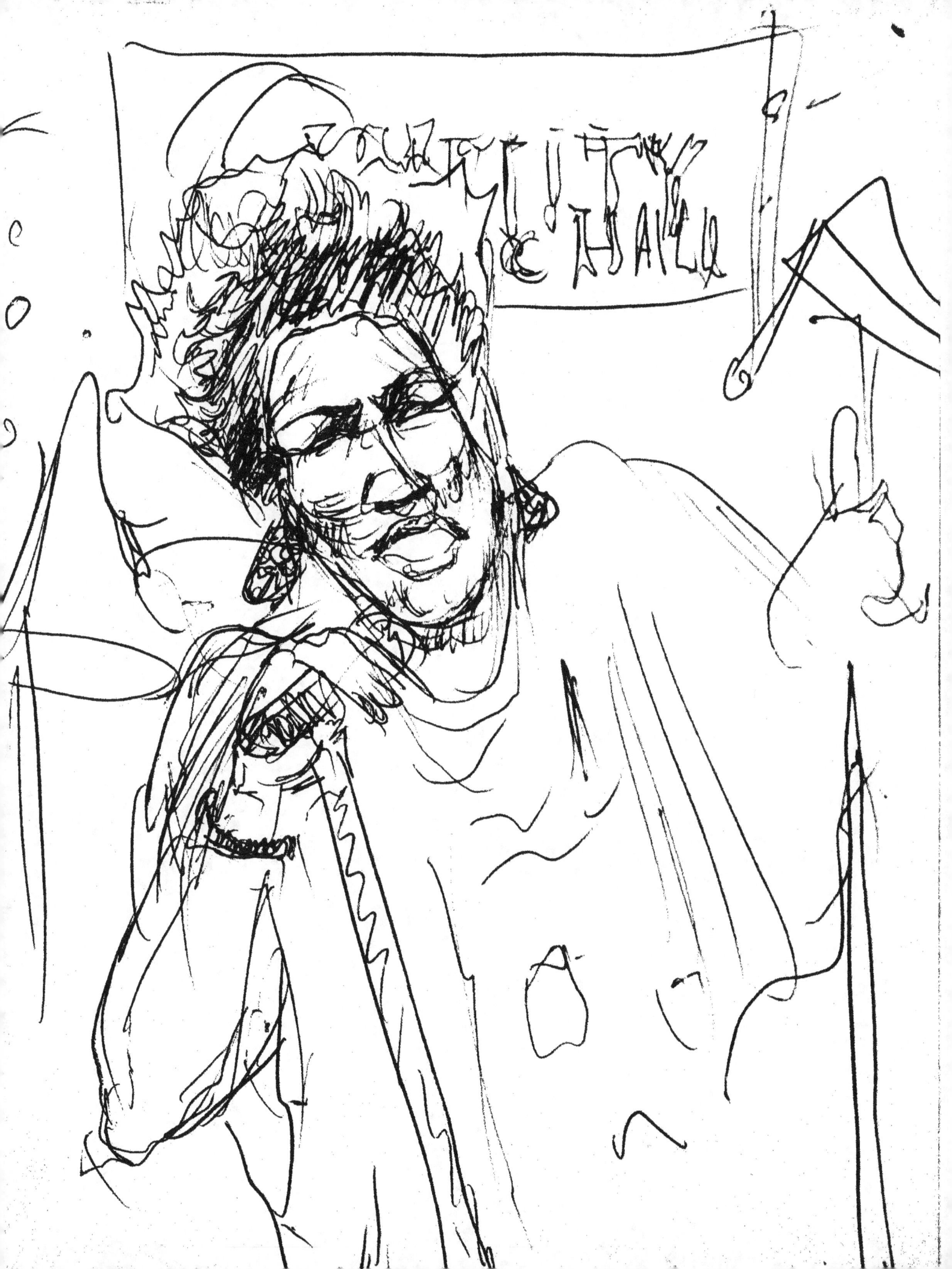

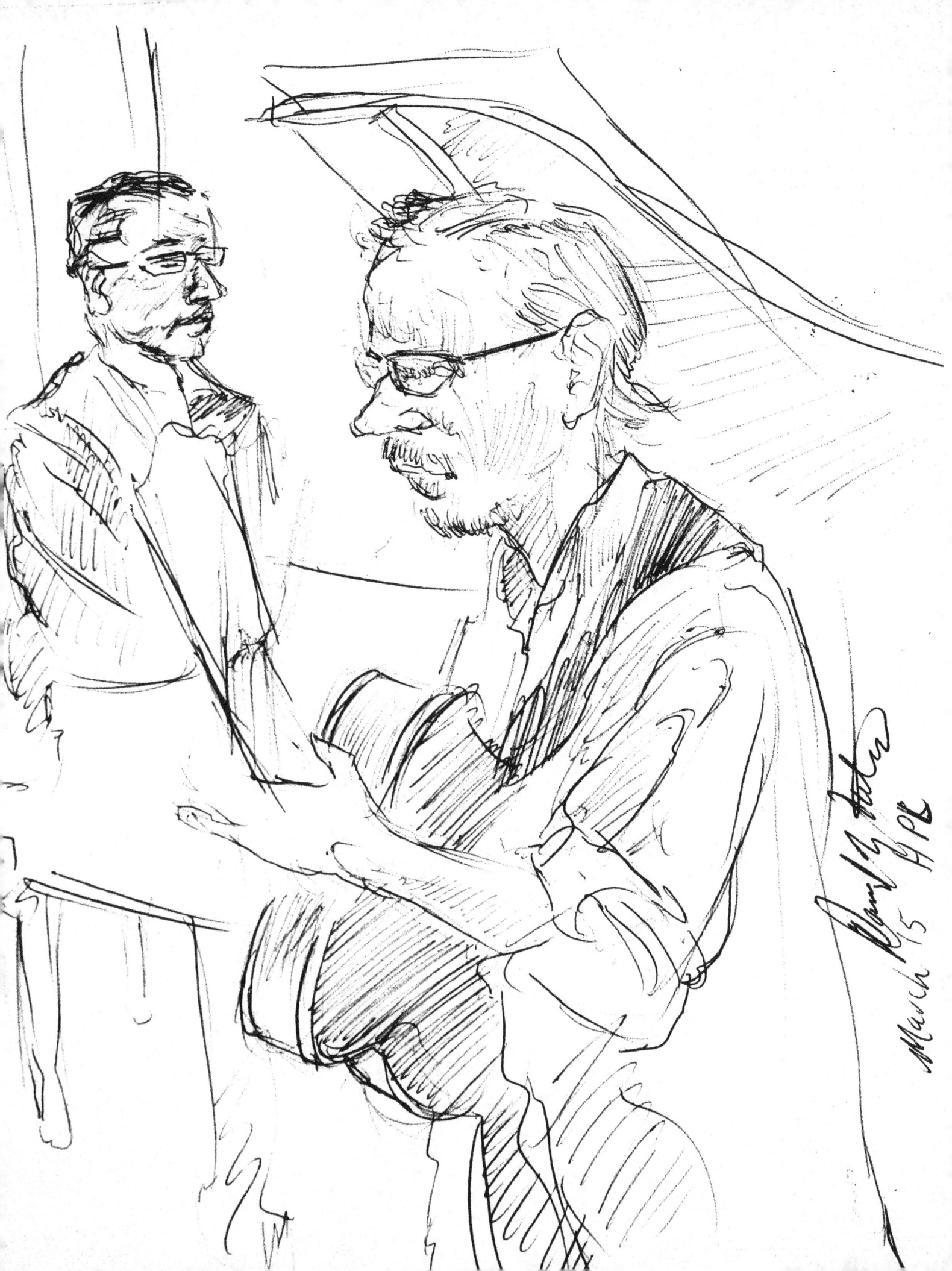

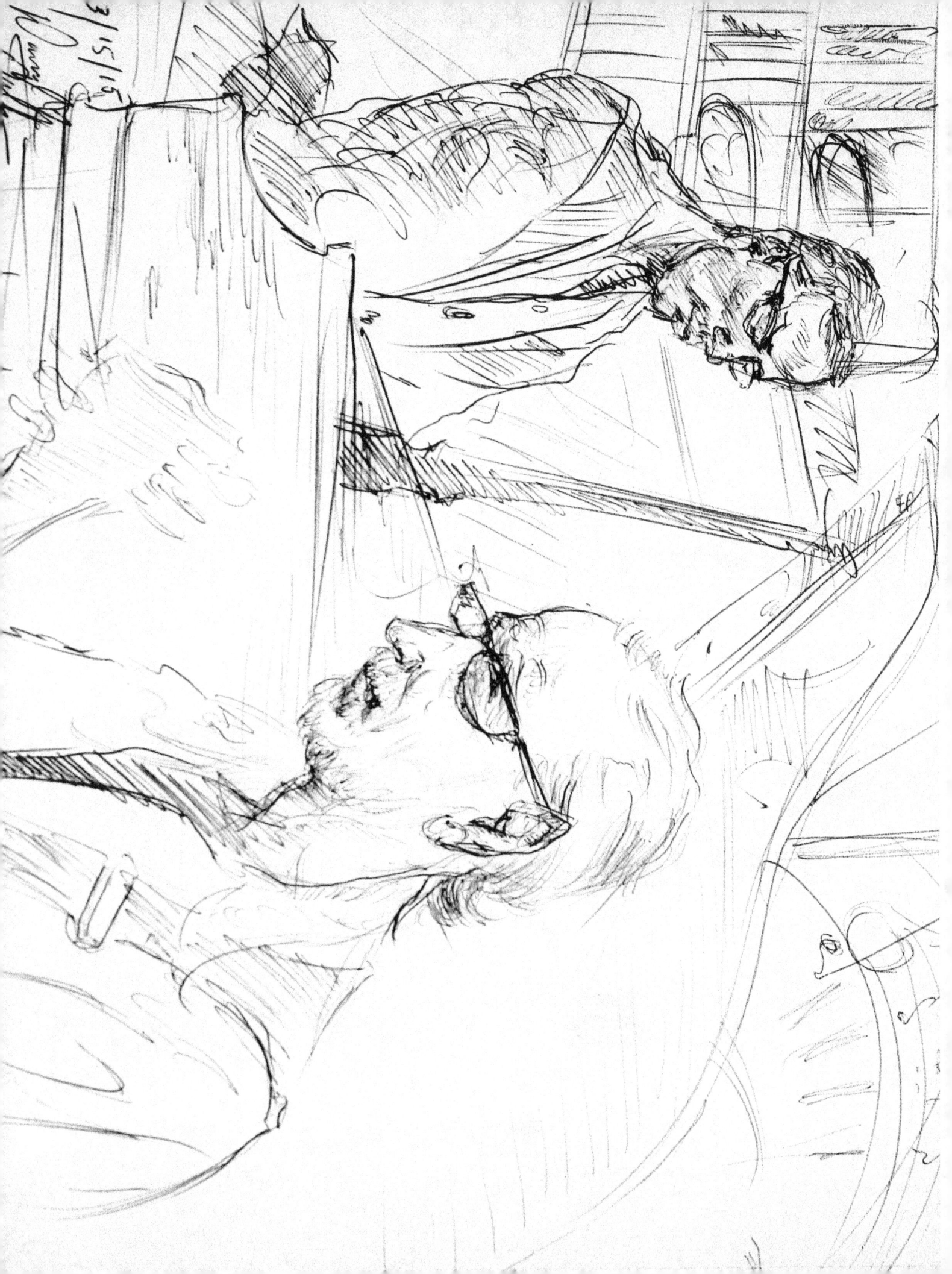

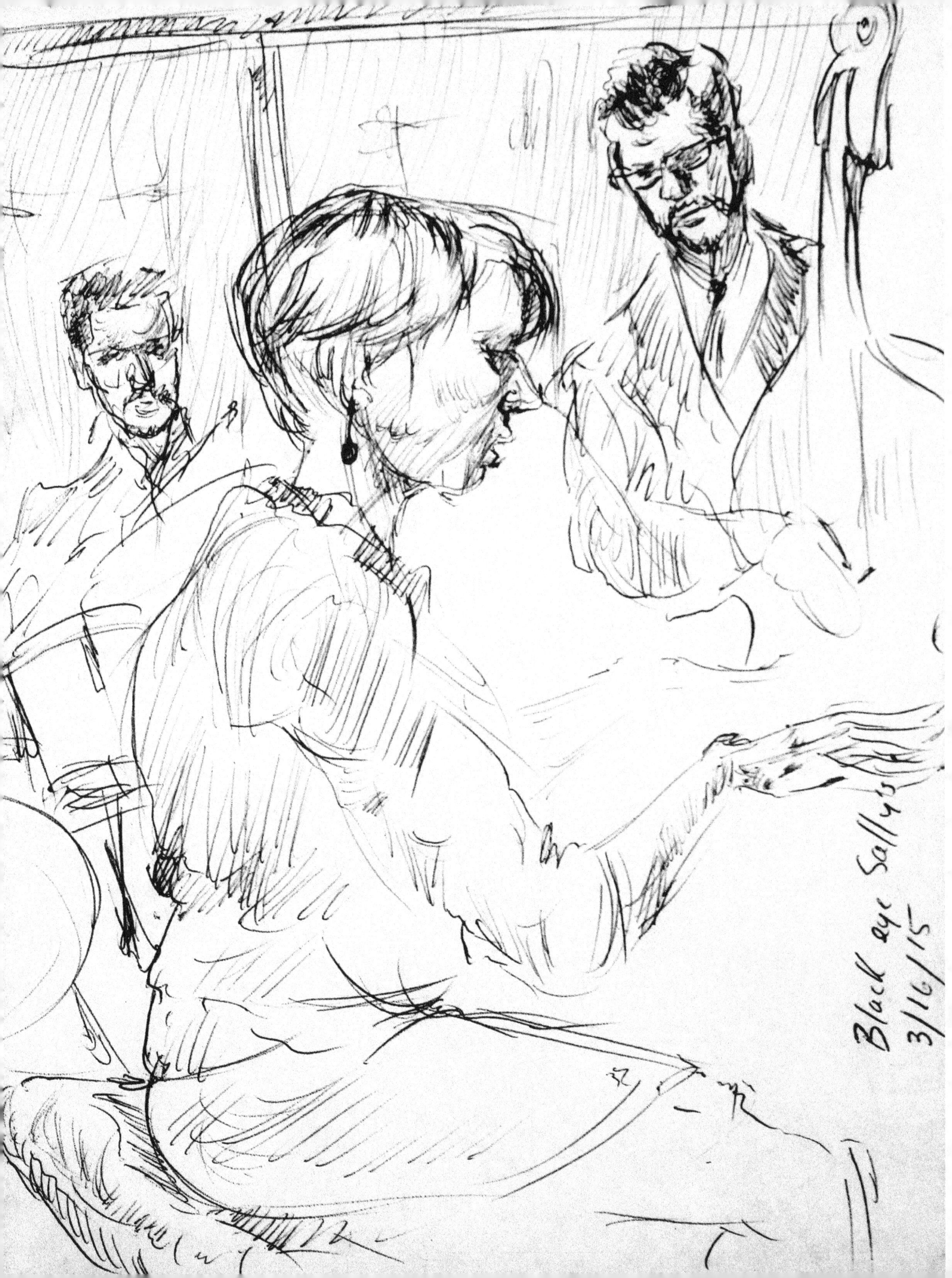
Black eye Sally's 3/16/15

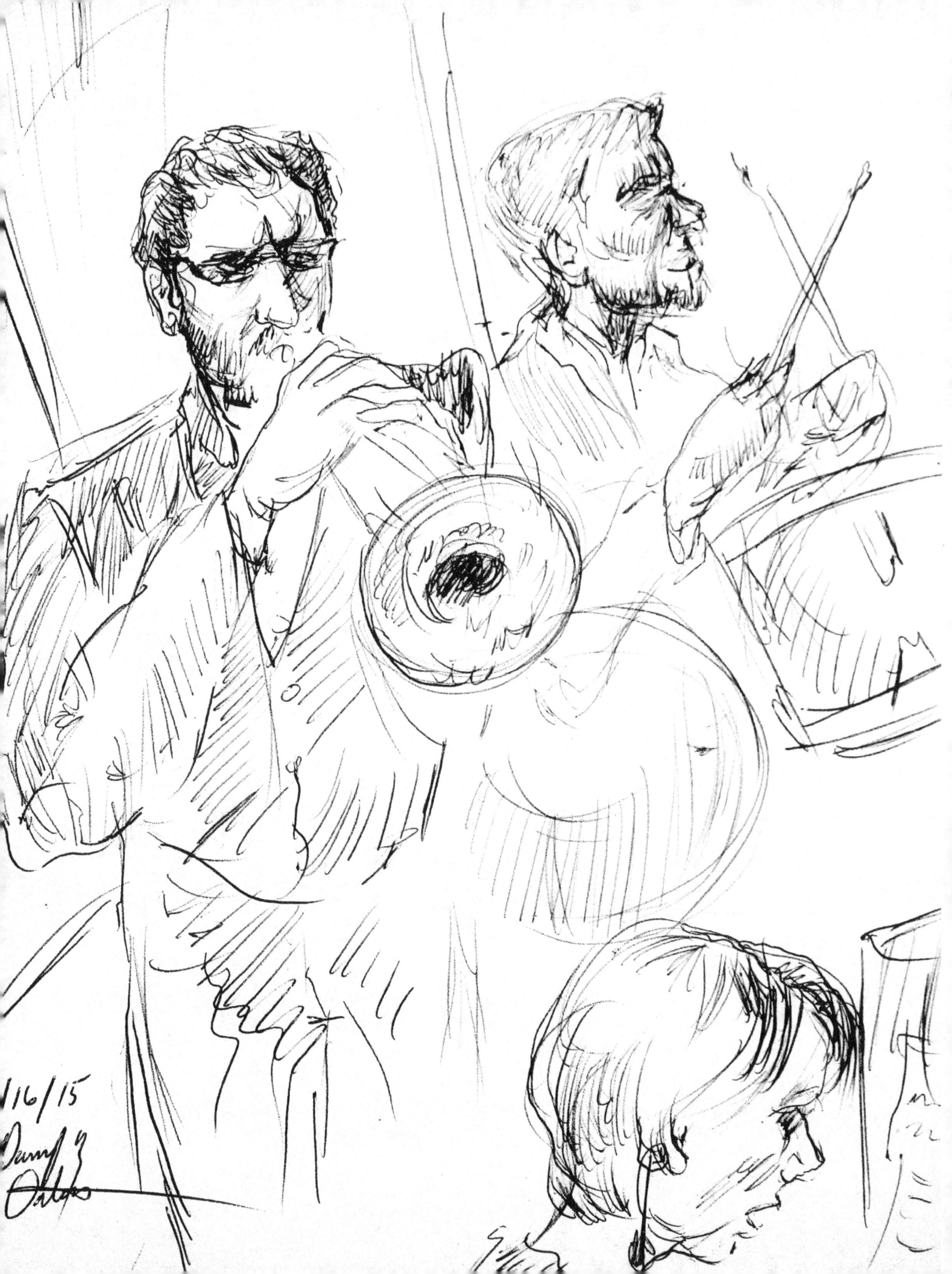

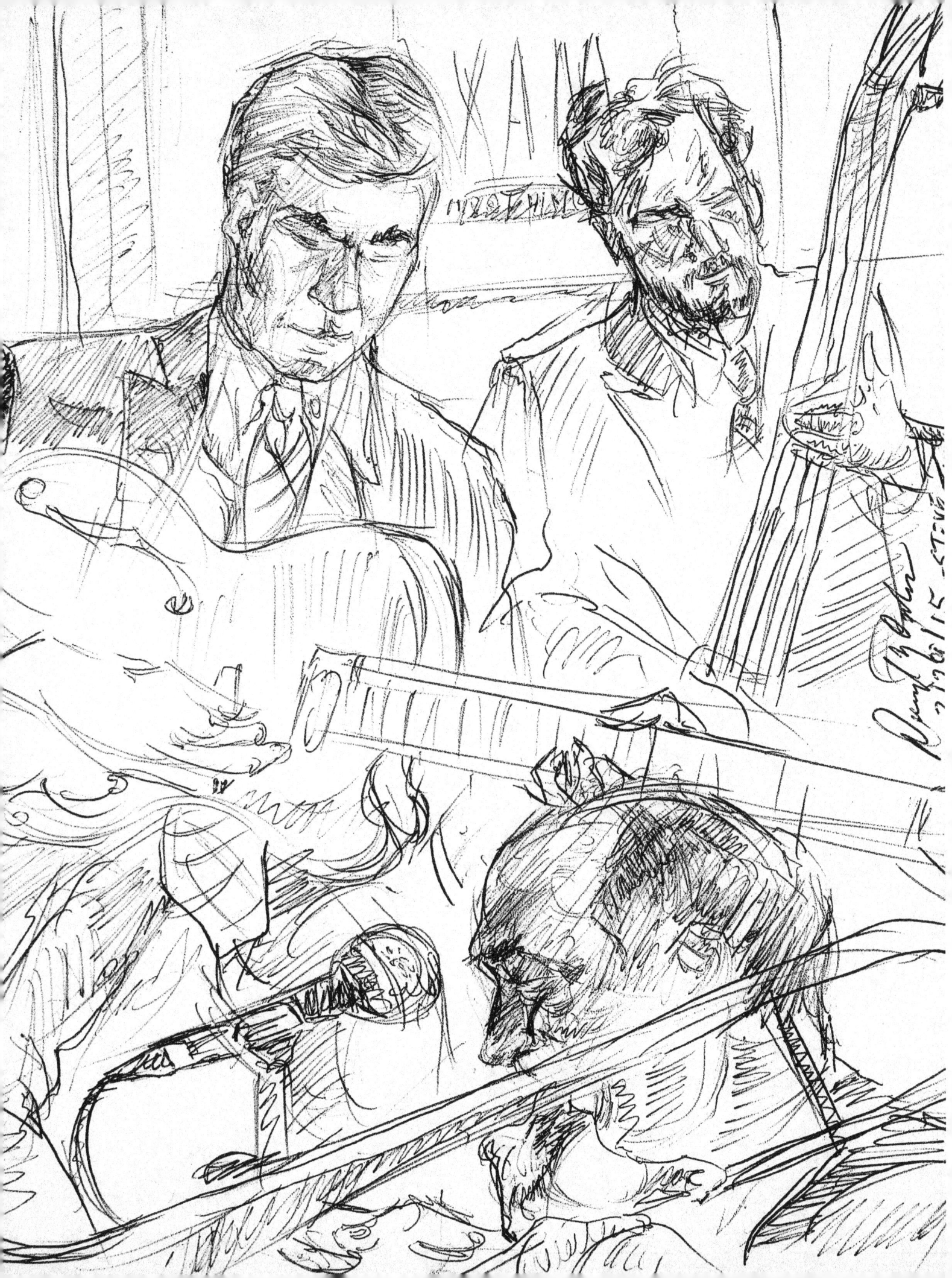

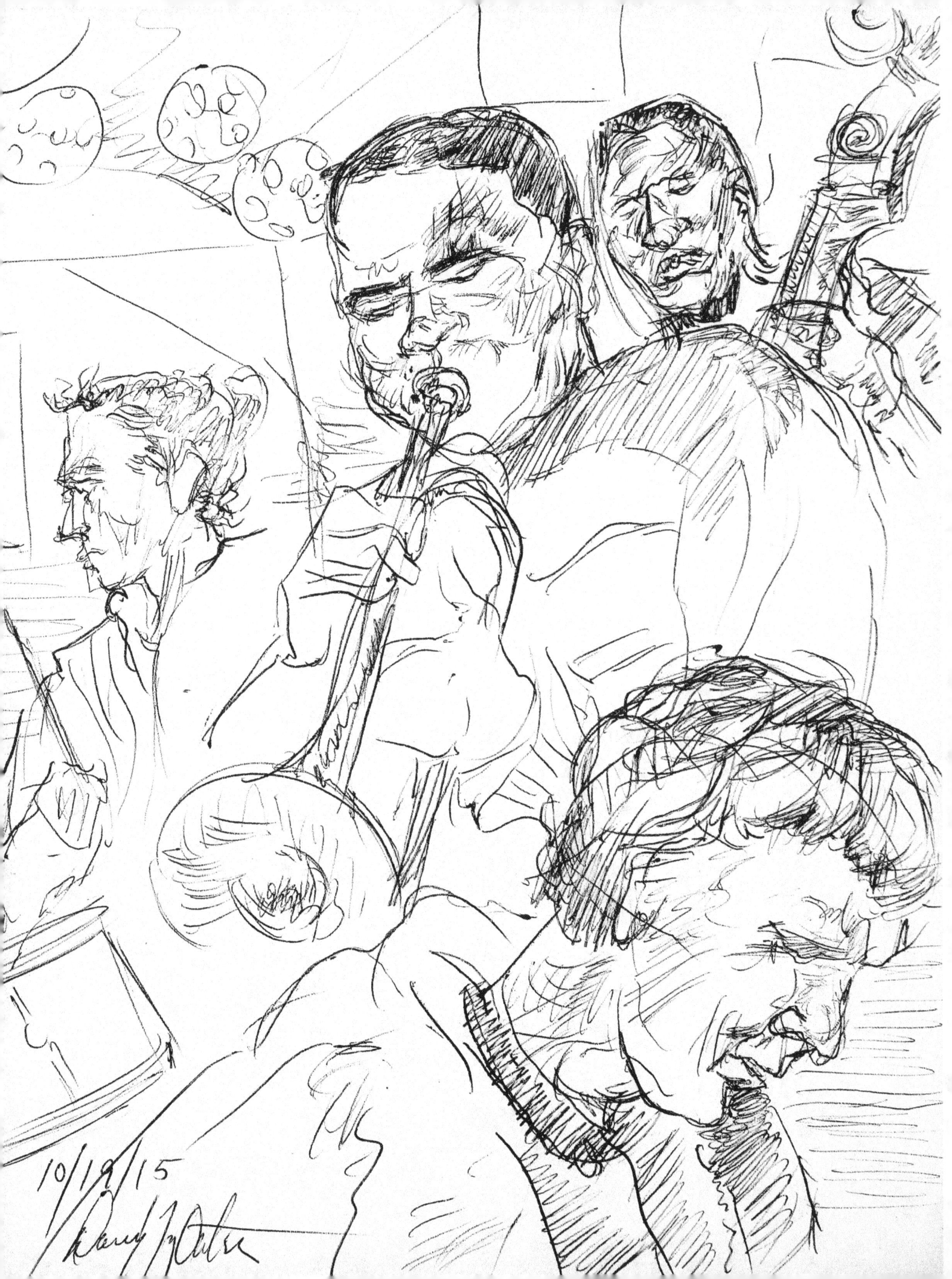

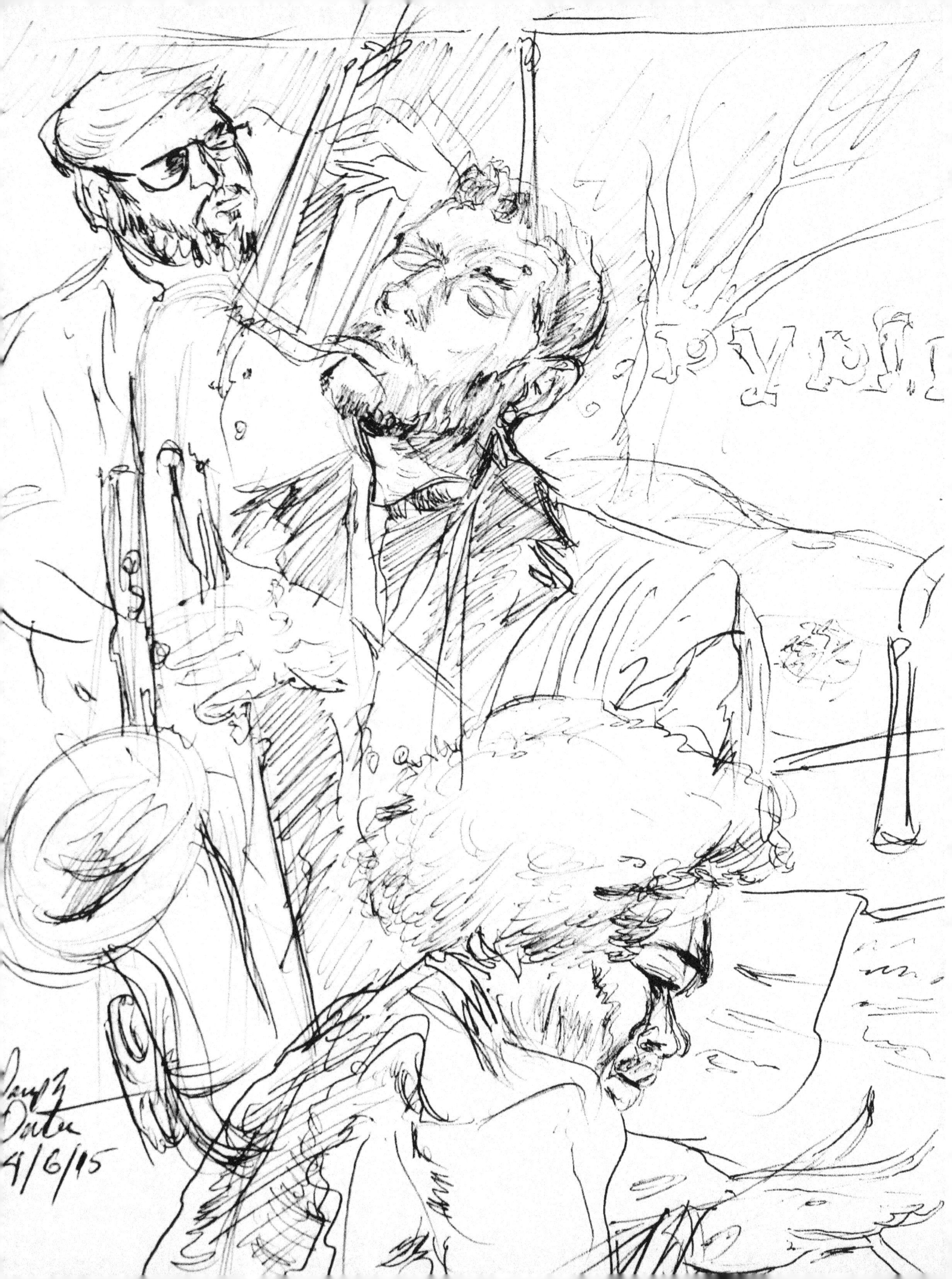

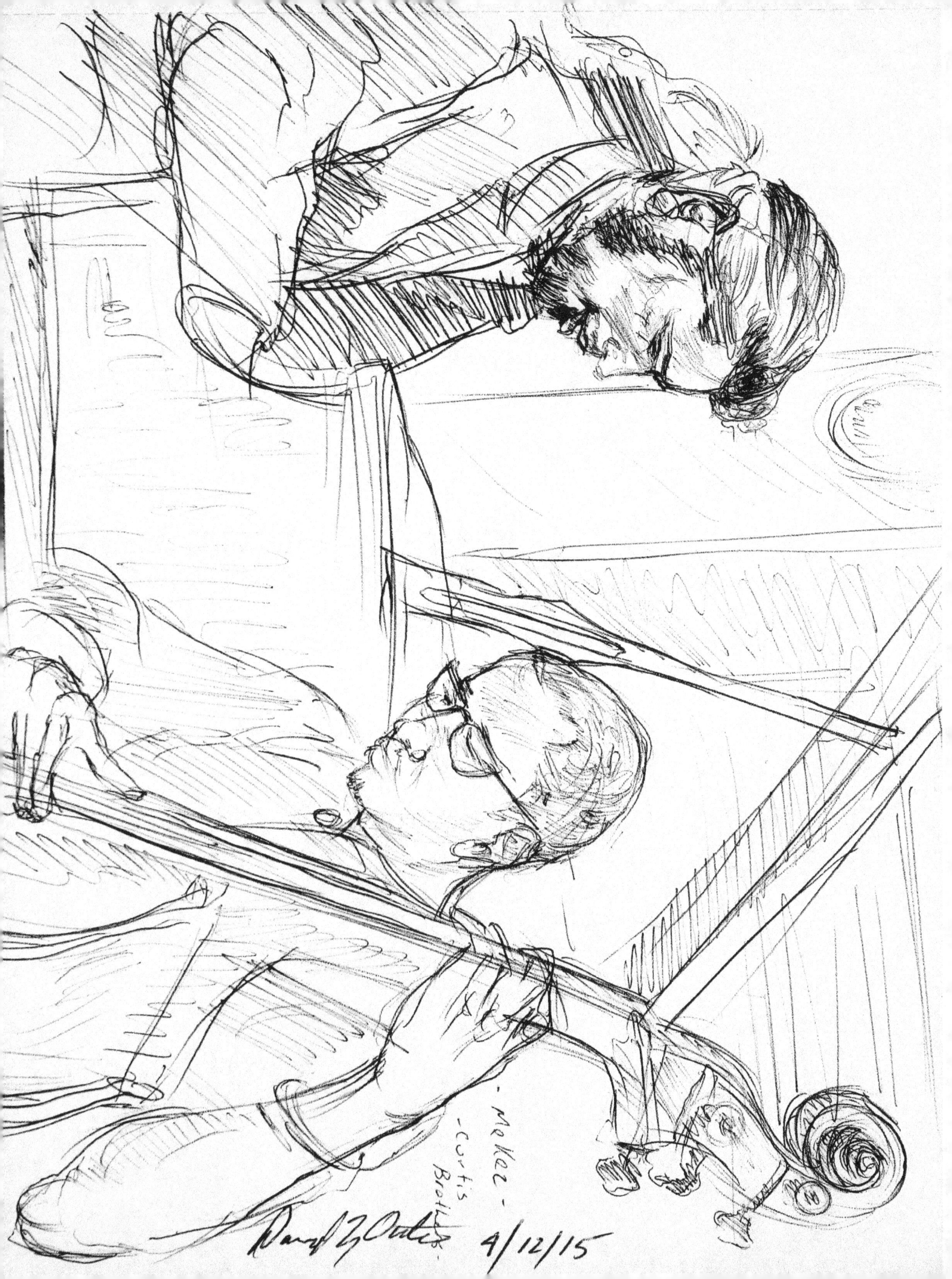

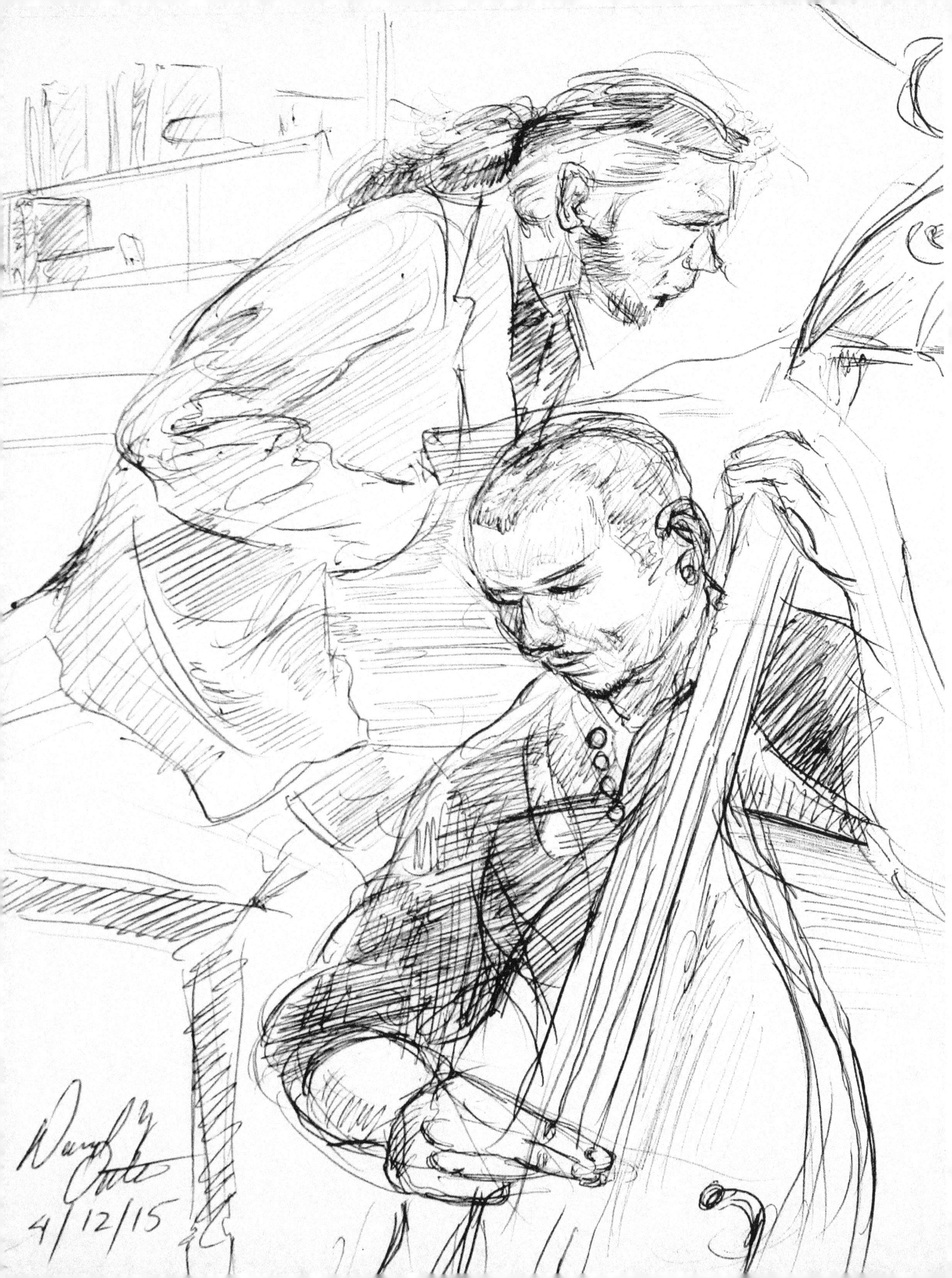

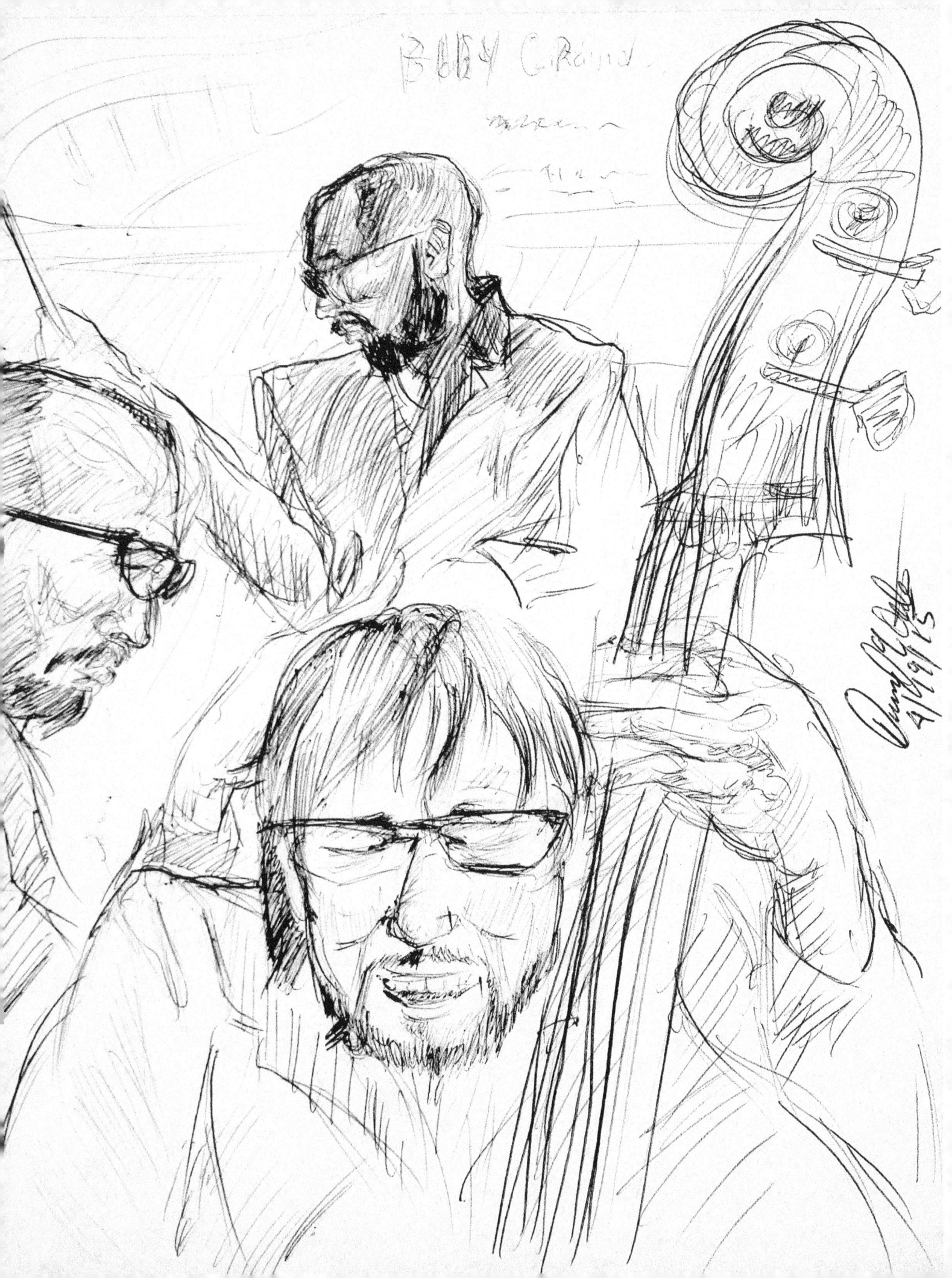

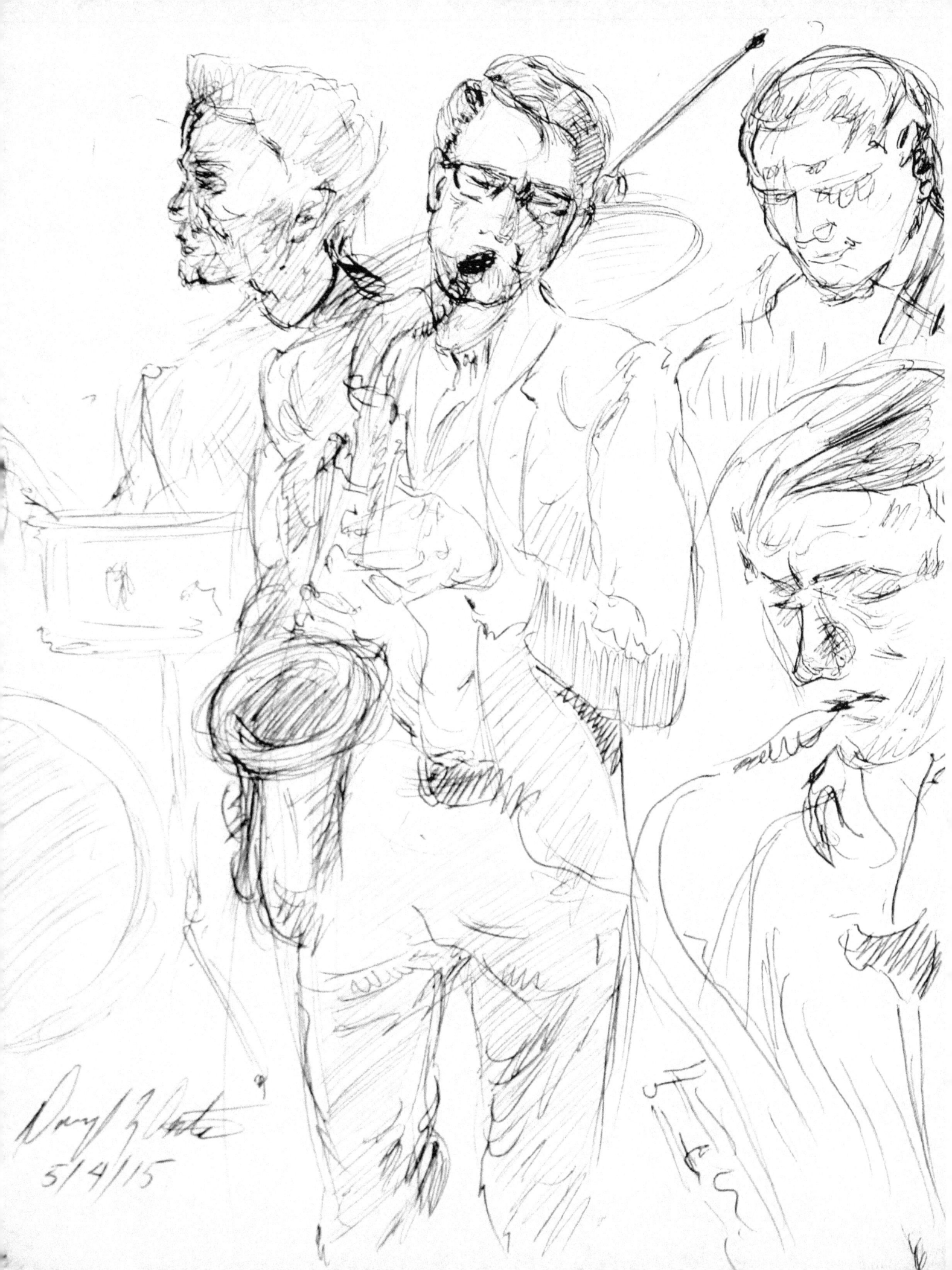

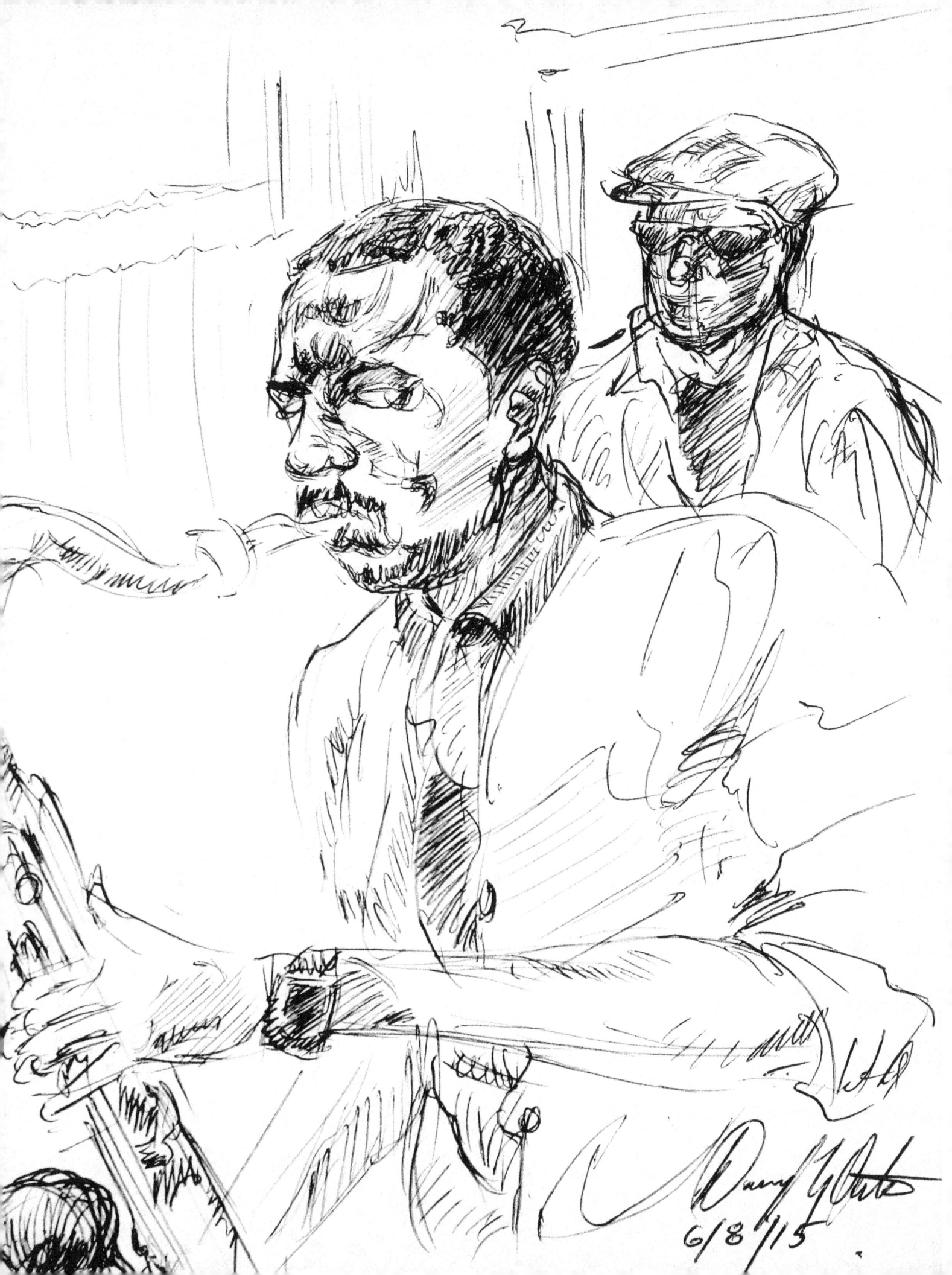

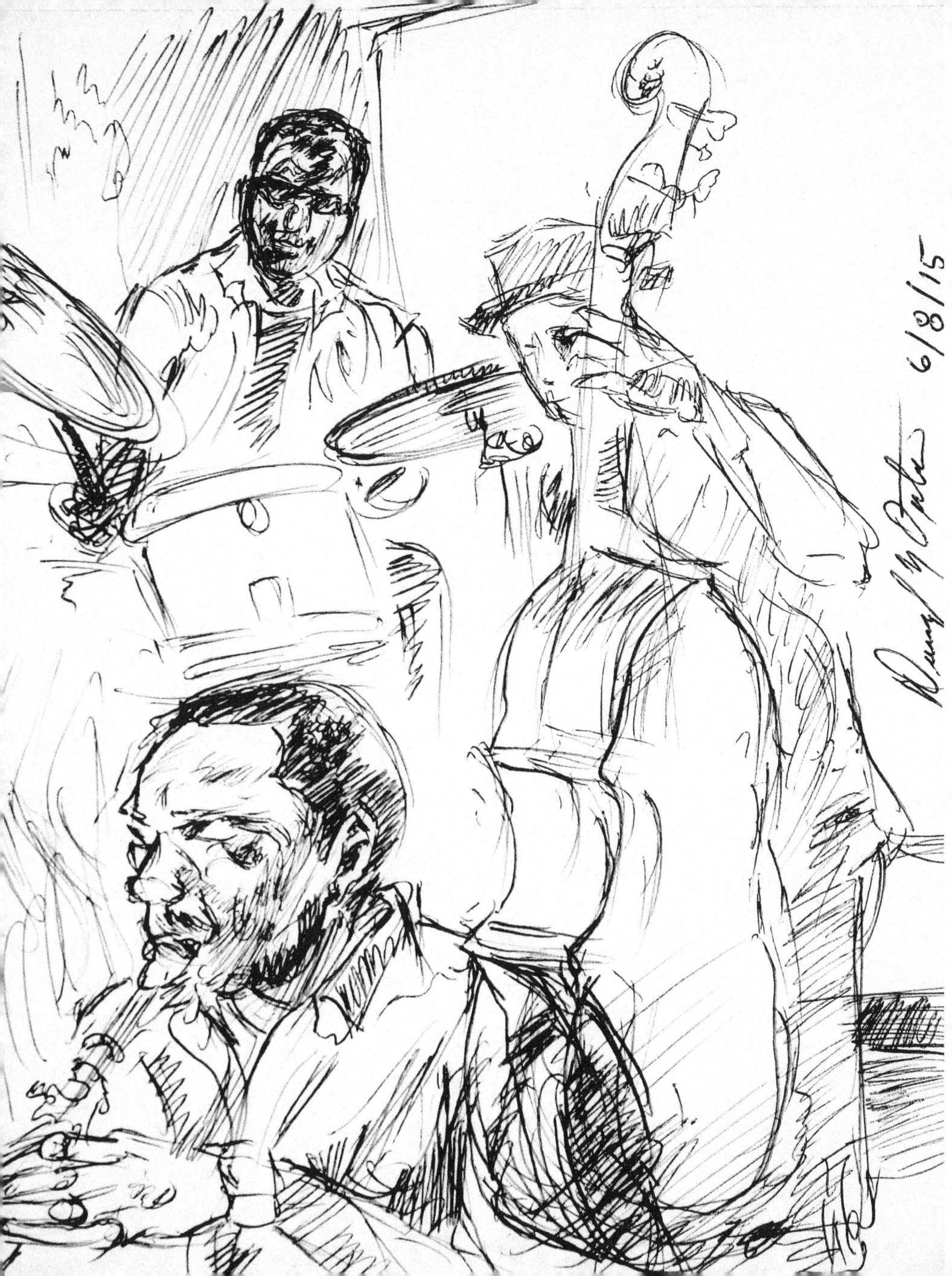

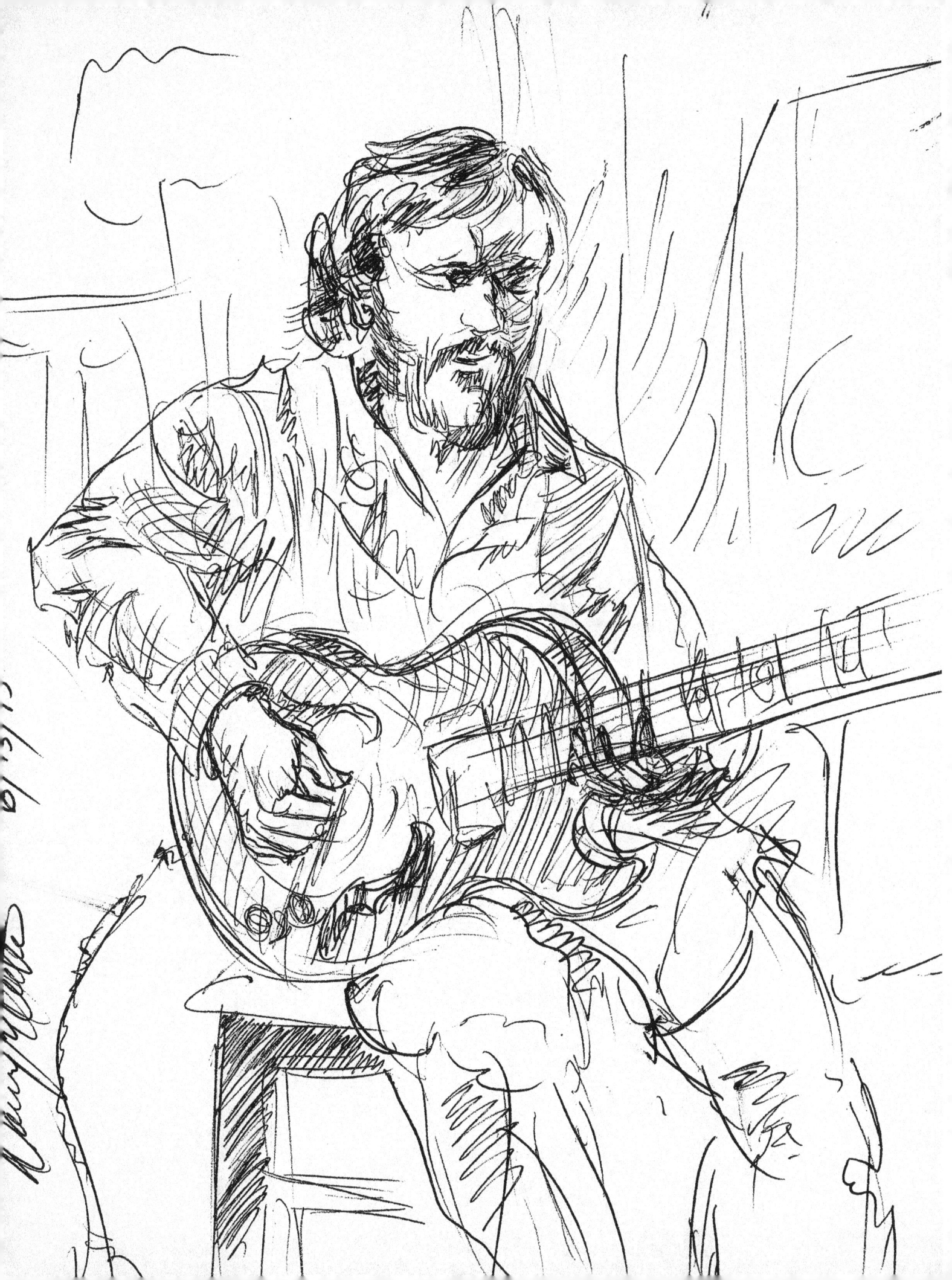

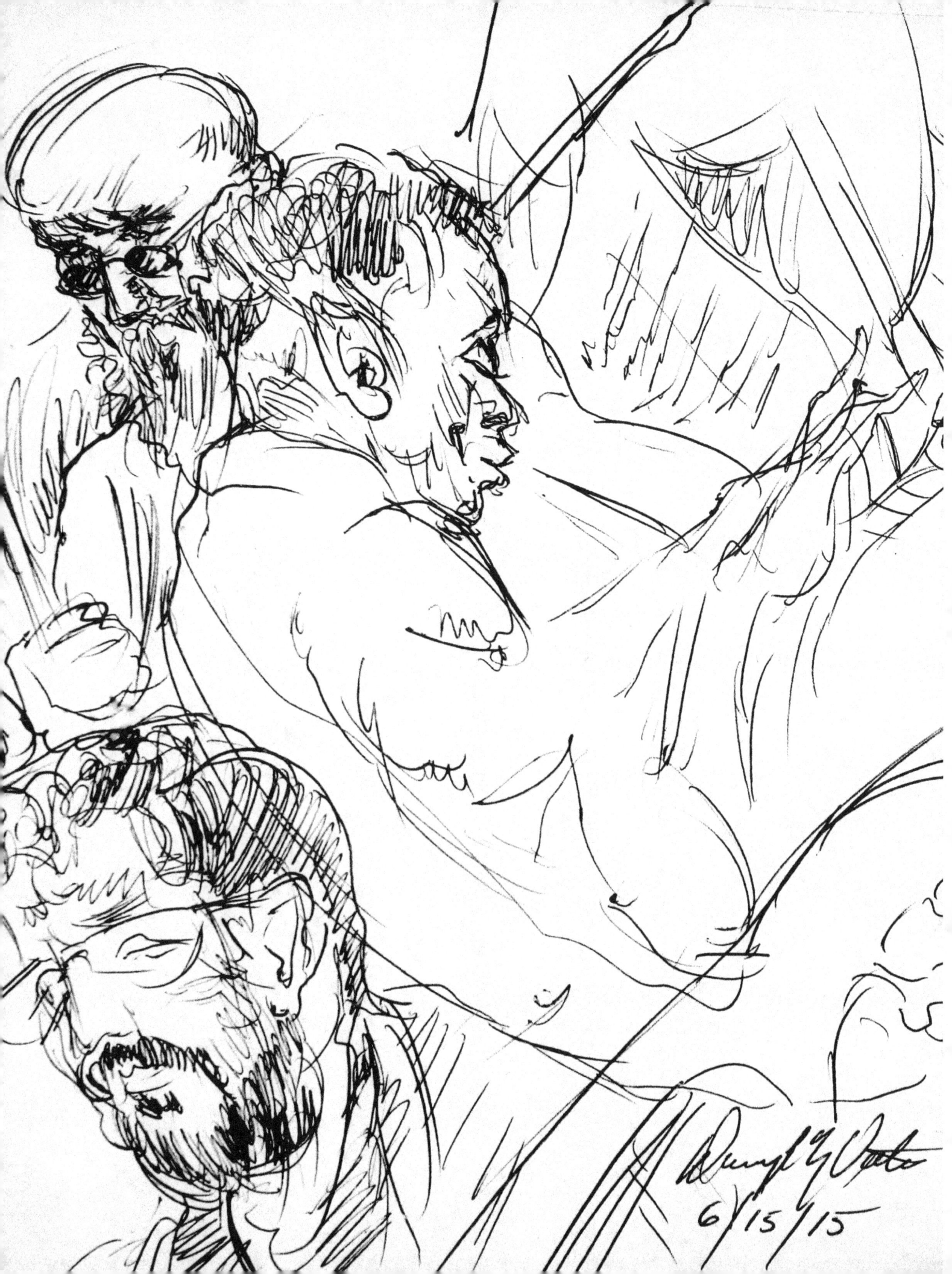

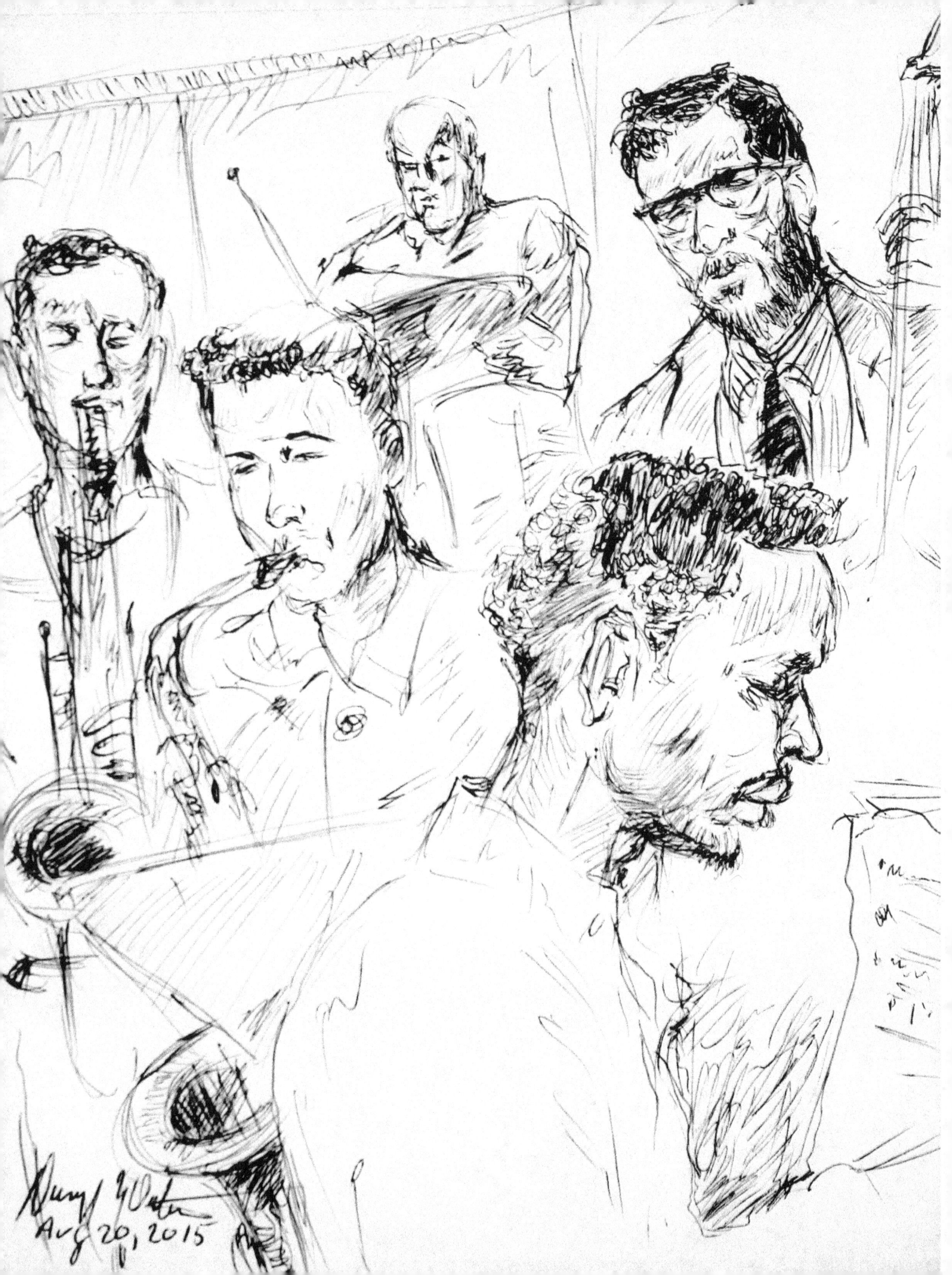

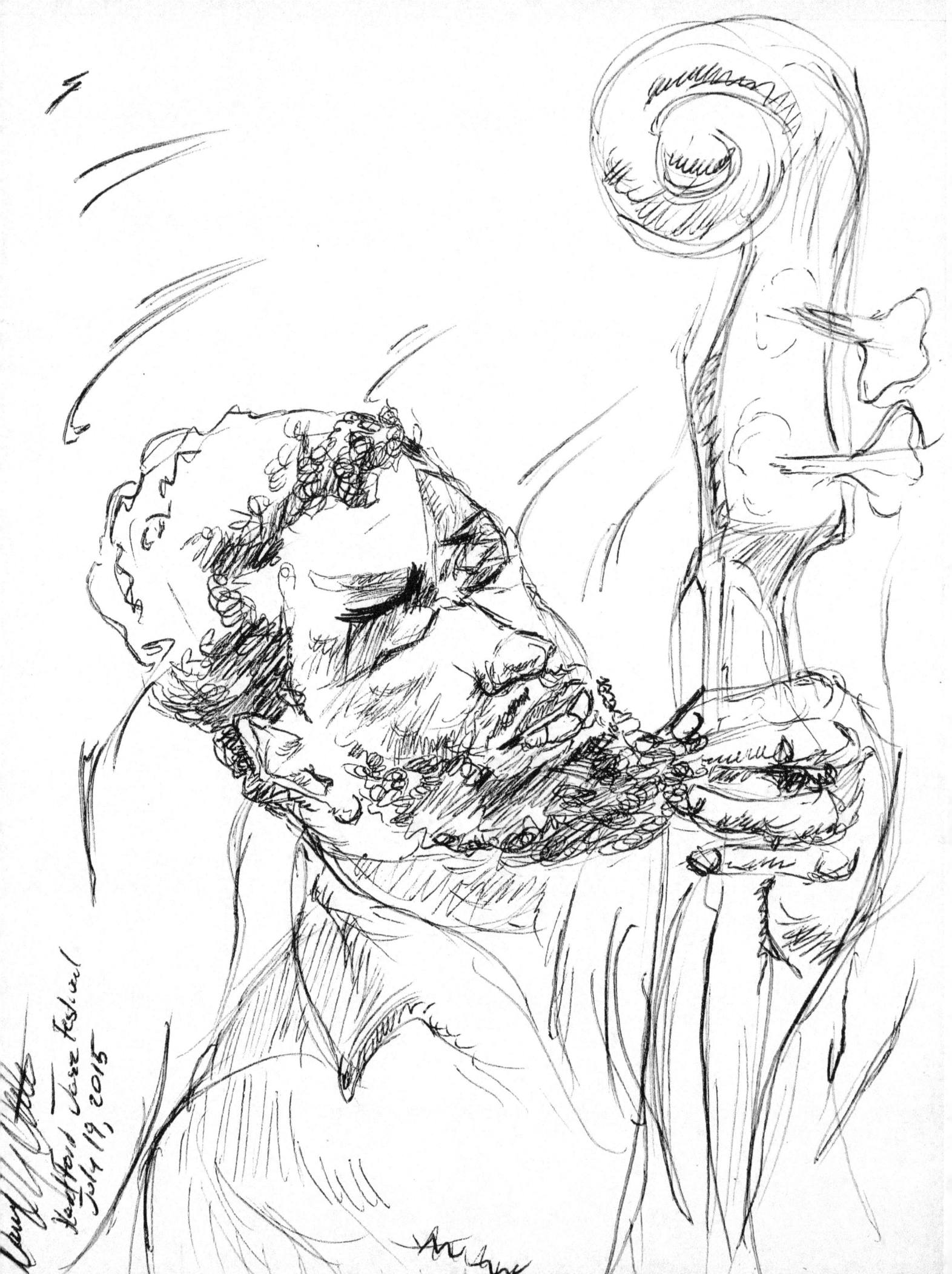

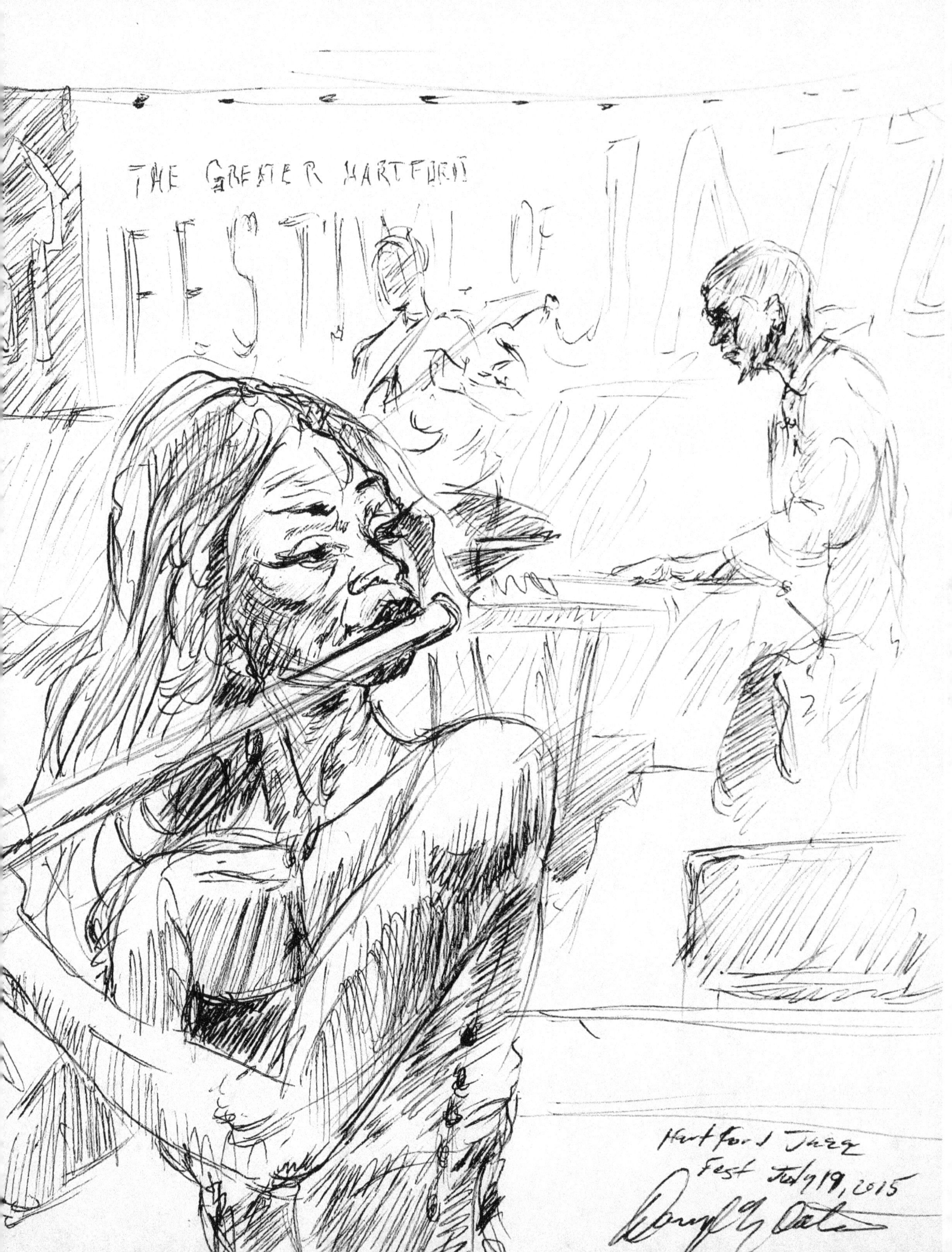